how to take
GREAT PET PICTURES

RECIPES FOR OUTSTANDING
RESULTS WITH ANY CAMERA

Ron Nichols

AMHERST MEDIA, INC. ■ BUFFALO, NY

For Stinker, Tiger, Bogey, and Skippy.
Thank you for your friendship and loyalty.

Copyright © 2002 by Ron Nichols.
All photographs by the author unless otherwise noted.

All rights reserved.

Published by:
Amherst Media, Inc.
P.O. Box 586
Buffalo, N.Y. 14226
Fax: 716-874-4508
www.AmherstMedia.com

Publisher: Craig Alesse
Senior Editor/Production Manager: Michelle Perkins
Assistant Editor: Barbara A. Lynch-Johnt

ISBN: 1-58428-066-2
Library of Congress Card Catalog Number: 2001 132038

Printed in Korea.
10 9 8 7 6 5 4 3 2 1

Table of Contents

Acknowledgments

For sharing their pets and for being photographic subjects: the Kida Family, the Peterson Family, Jenny Bennett, Janice Richardson, The Rocky Mountain Search and Rescue Association.

For their talents and skills in editing and packaging this book: Publisher Craig Alesse, Editors Michelle Perkins and Barbara A. Lynch-Johnt. And to Johanne Murdock for the idea.

For their love and support: Betsy and Katie Nichols (and Skippy).

Introduction

They give us unconditional love. They give us joy. They are our pets.

It is hard to imagine what our lives would be like without them. They come in all shapes and sizes, breeds, colors, dispositions, and even species. But at some basic level, we want and need them to be a part of our lives.

They ask for little. Never criticize. Never pass judgment. They make our lives richer. In return, we give them our love and our care. But for all that we do for them, it seems that pets always do more for us.

Looking back at my childhood calls to mind the rich memories of my first dog, Stinker. (The name was given to him as a result of his inquisitive, not his odoriferous, nature.) Like most of my pet friends, Stinker was always there for me—always happy to see me, to play with me, and sometimes to be ignored by me. It didn't matter what day it was, or what time it was, or even what the weather was—Stinker was always ready to play with me and to be with me. Through Stinker I learned about real friendship and unconditional love.

IT DIDN'T MATTER WHAT DAY IT WAS, OR WHAT TIME IT WAS—STINKER WAS ALWAYS READY TO PLAY WITH ME.

And when he died, I learned how it felt to have my heart break—to lose a close and beautiful friend. Stinker taught me that even in death, love lives on.

More than thirty years later, my old friend still chases me in the warm sunshine that lights the backyard of my boyhood memories. Luckily, I even have a few photographs of Stinker and me together—images my mother took with her Brownie camera.

I can't tell you how precious those black and white images are to me. Obviously, they will never replace my friend, but they do sharpen and enhance my memories of the times we had together.

Pet lovers continue to take pictures of their loving animal friends. Many of my basic photography students at the University of Utah choose their own pets as subjects for their various photographic assign-

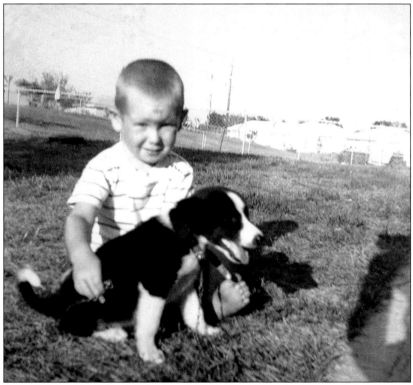

Photos help preserve treasured memories—like time spent with my childhood dog Stinker. Photo by Jean Nichols.

ments. I'm delighted when they apply solid photographic principles to their pet photography endeavors and create images that become cherished keepsakes—keepsakes that will undoubtedly be as important to them as those pictures of Stinker are to me. Playing a role in helping them take those wonderful images is one of the most rewarding aspects of teaching.

I've written this book so pet lovers throughout the world can make better pictures of their special friends, creating treasured keepsakes of their pets. Like other genres of photography, pet photography can be both challenging and extremely rewarding. I hope you enjoy learning how to take great pictures of your pets, but most importantly, I hope you enjoy and celebrate every moment you have with them.

MOST IMPORTANTLY, I HOPE YOU ENJOY AND CELEBRATE EVERY MOMENT YOU HAVE WITH THEM.

I believe this book will help you become a better pet photographer—just as our pets help us become better people.
—*Ron Nichols*

1

TOOLS OF THE TRADE

*Cameras and Film for
Pet Photography*

Among the many questions I field each semester from my university students, which camera to buy is always at or near the top of the list. It is a good question, and one that almost every photographer must grapple with. It is not, however, a question that can be answered by anyone but the person who'll be using the camera. The reason? Cameras don't take pictures, people take pictures—cameras are simply tools for creating those pictures. The key to finding a camera that is right for you is in finding a camera that feels natural, fits your personal and technical needs, and is well matched to the photographic environment in which you most frequently create images of your pets.

☙ *Selecting a Camera*

Cameras, like cars, come in all shapes, sizes, and costs. Like cars, you can get economy models with limited features, or you can get luxury models with many special features. As a working photojournalist, I need

cameras and lenses that are rugged and that give me maximum creative control in taking pictures. However, the point and shoot features of smaller compact cameras make them a popular all-around choice for many pet owners.

If you desire maximum creative control, you'll probably want to invest in a 35mm camera with manual exposure and focusing controls. If you're intimidated by the thought of manually adjusting your camera's exposure and focusing controls, an "auto-everything" 35mm camera will suit your needs.

IF YOU'RE JUST GETTING STARTED, YOU MAY WANT TO ASK OTHER PET OWNERS WHICH CAMERAS THEY USE AND WHY.

You'll obviously purchase a camera that is within your budget. If you can afford it, it is a good idea to get a camera that has a built-in flash and a zoom lens. Make sure that whatever camera you're considering fits your "technical comfort zone," too. In other words, make sure you're comfortable with its use and operation before you buy.

It is always best to thoroughly research several cameras before you make a purchase. A camera is an investment that should last for years. If you have lots of photographic experience, you may already know what special features you'd like in your next camera. But if you're just getting started, you may want to ask other pet owners which cameras they use and why. You might also want to ask the

Point and shoot cameras generally feature auto-exposure and auto-focus in an easy-to-carry package. (Photo courtesy of Pentax)

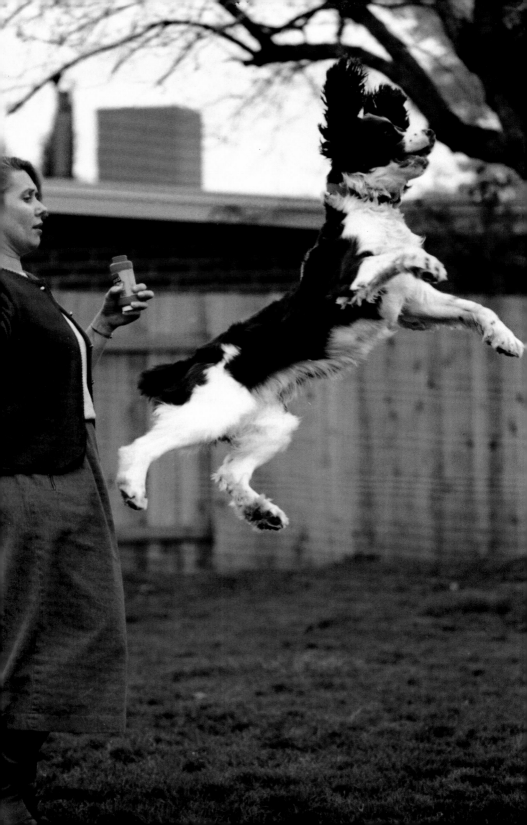

OPPOSITE PAGE: Simple point and shoot cameras provide consistent results under most conditions. But if you want more creative control (like choosing a fast shutter speed to freeze the action seen here) you'll want to purchase a camera that gives you advanced exposure control options. Once you've made such a purchase, enroll in a basic photography class at a local community college to master advanced photographic techniques.

sales representatives at several local camera stores about various cameras and their features. Photography magazines and Internet web sites also provide a wealth of information regarding cameras, features, and prices.

Although there are many models, brands, and features from which to choose, there are four major groups of cameras.

POINT AND SHOOT CAMERAS. Sometimes referred to as lens shutter cameras, point and shoot cameras are compact, easy to use 35mm and Advanced Photo System (APS) cameras. They generally feature automatic exposure control and automatic focus so you can just "point and shoot" when tak-

Advanced Photo System (APS) cameras offer features similar to those found in point and shoot cameras in an advanced film format that provides ease of film loading and multiple picture formats. (Photo courtesy of Pentax)

ing a picture. Because they are so compact, easy to use, and often feature zoom lenses (see illustration on page 16), they are ideal for capturing candid pet photos. And because they are automated, they render acceptable photographs in most situations. They don't provide the creative exposure and focus control that single lens reflex cameras do, however.

APS Format

Although not likely to replace the versatile and popular 35mm format, the Advanced Photo System, with its easy-to-use features, offers amateur photographers several advantages:

- Smaller film size allows cameras to be smaller and easier to handle.
- A leaderless, drop-in film cartridge prevents film-loading mistakes.
- Negatives are returned in the original cartridge, so there's no danger in mishandling the film. Keeping track of the negatives is also easier.
- APS photographers can choose between three print formats (including panoramic) and can change the format at any time during the roll.
- For ease of filing and reprinting, an index print is provided along with the processed prints, showing all of the positive images on a single print.
- Information regarding the shooting conditions is recorded on a special magnetic track on the film. This information helps film processors render higher quality prints.

SINGLE LENS REFLEX CAMERAS. The most popular choice of camera for photojournalists and advanced amateur photographers, 35mm single lens reflex (SLR) cameras provide greater exposure control and feature interchangeable lenses, so you can

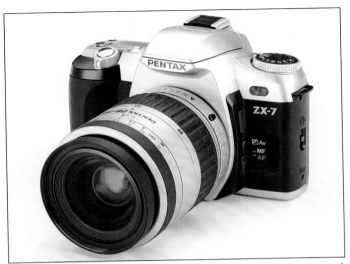

Single lens reflex cameras provide greater exposure control and feature interchangeable lenses, among other options. (Photo courtesy of Pentax)

shoot with a variety of lenses—from wide angle to macro to telephoto. Although SLRs are more expensive than point and shoot cameras, the SLR's ability to take new lenses allows for a greater range of shots and is a significant creative advantage.

Unlike point and shoot cameras, which allow you to preview an image through a window near the lens, SLR camera systems use a mirror and viewscreen that allow you to preview an image through the lens itself. Because the photographer can look through the camera's lens and see what the lens sees when taking the picture, he can compose the picture more accurately. Most SLRs also come with automatic or programmable exposure controls. Many feature automatic focus control as well.

SINGLE USE CAMERAS. Single use (disposable) cameras are inexpensive cameras that are preloaded with film. Disposable cameras are designed for gener-

al use, underwater use, or for shooting panoramic photos. Some come equipped with a built-in flash. Once you've exposed all of the film in the camera, you simply take the camera to a film processing store; your prints are returned to you, but the camera is not. Because disposable cameras are inexpensive and easy to use, they are perfect for use by guests at special functions like parties, weddings, or receptions.

DIGITAL CAMERAS. Rather than recording images on light-sensitive film, digital cameras record images in an electronic or digital format. Photos taken with a digital camera can be viewed on a computer immediately after taking them. The resulting images can be manipulated, duplicated, and transmitted electronically over the Internet to anywhere in the world.

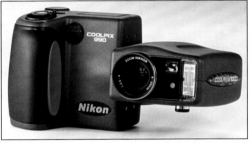

Digital cameras offer many of the features of point and shoot cameras, but record images in an electronic format rather than on film. (Photo courtesy of Nikon)

Once you've chosen the camera and format that are right for you, heed this advice: Prior to taking your first picture, read the owner's manual for the camera from beginning to end so you're familiar with its overall operation. It details how you can use the camera's special features to help you take better photos. The owner's manual is also an invaluable source of information on the camera's care.

☀ *Camera Lenses*

THE VERSATILE ZOOM. Whether you use a point and shoot, SLR, single use, or digital camera, your camera

may very likely come with a zoom lens. Zoom lenses offer a variety of lenses all rolled into one. With the push of a button (for automatic zooms), you can achieve shots typically made by normal, wide angle, and even moderate telephoto lenses. Zoom lenses reduce the time spent changing lenses and moving closer and further from your subject, and are easier to carry than a camera bag filled with lenses. A typical zoom lens for a point and shoot camera is 28–85mm. The numbers represent the focal length of the lens—the smaller the number, the wider the angle; the bigger the number, the

YOU CAN ACHIEVE SHOTS TYPICALLY MADE BY NORMAL, WIDE ANGLE, AND EVEN MODERATE TELEPHOTO LENSES.

tighter the angle. In the case of a 28–85mm zoom, the widest angle is 28mm and the tightest angle is 85mm. You can also use all of the focal lengths in between.

THE WIDE ANGLE. When using a wide angle lens (16–40mm), objects appear further away than when viewed with the naked eye. The angle of view is also wider than is seen with the eyes focused in a fixed position. The wide angle allows you to increase the area you see when you look through your lens, and thus allows you to include more of the scene in your composition. Wide angle lenses work well for shooting scenics, group shots, and even for some portraits. A potential drawback to using wide angle lenses, however, is distortion. Objects photographed close with a wide angle lens appear disproportionately larger than objects further away. The wider the angle of view, the greater the potential distortion. Consequently, wide angle lenses are not considered ideal for close-up portraits since they create distortion of facial features.

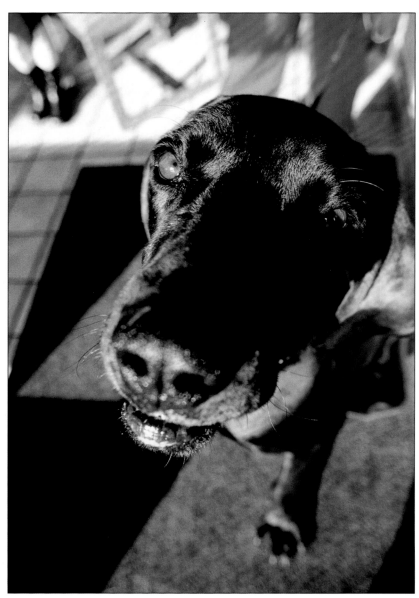

Many point and shoot cameras come with zoom lenses. These lenses provide multiple focal lengths (angle of views) in one. Here, a wide angle lens (28mm) is used at a distance of about two feet. Notice how large the dog's nose appears due to the wide angle distortion. This distortion can be used to add humor to a simple pet portrait.

THE NORMAL LENS. A normal lens on a 35mm camera is 45–55mm. This angle of view approximates the perspective you achieve in fixing your eyes on a particular scene. It is the standard lens sold with SLR cameras and is useful in many situations, including scenics, mid-length, and full-length portraits.

Normal lenses (50mm on 35mm cameras) provide a "normal" view of most subjects and are useful in a variety of shooting situations, including simple portraiture.

THE TELEPHOTO LENS. These lenses, which feature focal lengths greater than 55mm, are especially useful for mid-length and head and shoulders portraits, sports, candids, and some scenics. Telephoto lenses also yield images that seem to have been taken at a closer range, allowing you to get "closer" to scenes when you can't walk there. Telephoto lenses cover less background area than "normal" lenses. This simplifies and improves most portraits by eliminating distracting background clutter.

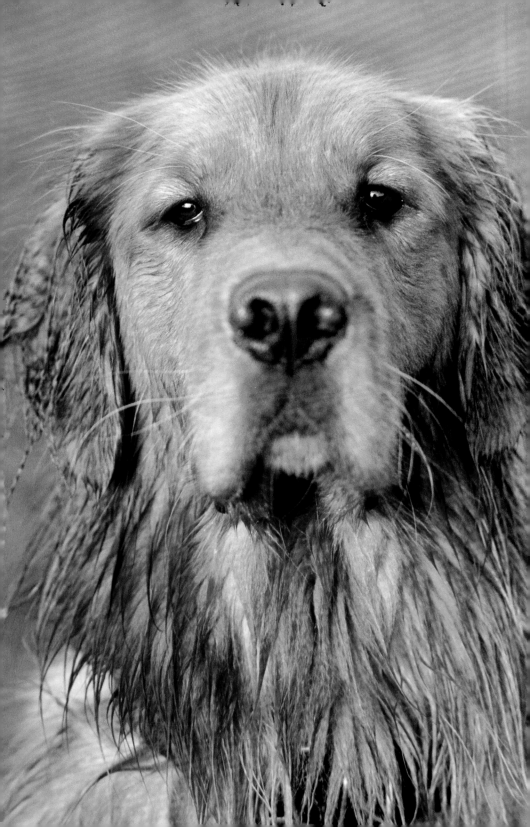

OPPOSITE PAGE: Here a telephoto (105mm) lens is used at about six feet from the subject. (Notice the narrow angle of view and how the background is soft and non-distracting.) Telephoto lenses are especially useful in creating portraits and for capturing images from a distance.

THE MACRO LENS. If you plan on taking close-ups of your pets, the macro lens is a valuable tool to have in your camera bag. Most normal lenses only allow for a minimum focusing distance of a couple of feet, but the macro lens allows you to focus on a subject that is only

IF YOU PLAN ON TAKING CLOSE-UPS OF YOUR PETS, THE MACRO LENS IS A VALUABLE TOOL TO HAVE IN YOUR CAMERA BAG.

inches away. This is especially helpful when photographing small pets or when attempting to make a very tightly cropped image of a pet's face (for more on this topic, see chapter 8).

Choosing Film

Film is the medium upon which your photographic images are made. Since light is the catalyst in capturing an image on film, the amount of light that is allowed to hit the film is very important. Properly exposed film will result in photographs that are neither too dark nor too light. Producing properly exposed images is, of course, your goal.

Film speed ratings (ASA or ISO numbers) tell your camera how much light must hit the film in order to make a properly exposed image. The higher the number of the film's rating (ASA or ISO), the more sensitive the film is to light. In other words, a film with an ASA of 400 is twice as sensitive to light as ASA 200 film, so only half as much light is needed to make an exposure of the same scene.

There's an inverse relationship between film speed and the amount of light that is required for proper exposure: the higher the speed, the less light

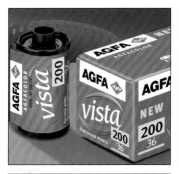
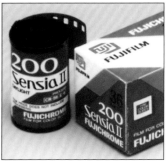

Color film is available in print (color negative) or slide (color transparency) formats from several manufacturers. You can select from a range of film speeds to fit almost any situation.

needed to take a properly exposed photograph. Higher-speed films tend to produce more grain on the final prints or slides. The larger the grain, the lower your photo's resolution. However, unless you're enlarging photographs to more than 8"x10", this shouldn't be a problem. (For larger prints [11"x14" to 16"x20"], a slower speed film [i.e., ISO 100] will provide the best results.) ASA 400 film will likely be your best bet in almost any situation (with the exception of big enlargements).

COLOR PRINT FILM. For most at-home applications, color print film will be the film of choice. As discussed earlier, when picking a color print film,

OPPOSITE PAGE: Because color film is so widely used today, choosing black and white film for your subject can help make a photograph truly unique. Custom photo labs can print your black and white images on archival paper that can last for hundreds of years in scrapbooks or in frames.

you'll probably want to choose a film with an ASA/ISO rating of 400. Kodak Royal Gold 400 and Fujicolor 400 are two excellent films.

COLOR TRANSPARENCY FILM. If you enjoy putting together slide shows, color transparency will be the film for you. Slides are also easier to file and catalog than prints.

BLACK AND WHITE FILM. If you're looking for variety, or perhaps a photo to accompany some old black and white prints, try shooting black and white film. For the best results, have your final images printed at a lab that specializes in black and white custom prints. You can have these prints toned and can even handcolor your black and white photos for a unique image.

Because few commercial photo labs offer traditional black and white processing, several manufacturers offer black and white film that can be developed with a color film process called C-41. This film (like Ilford's XP-2) gives photographers the opportunity to take black and white photos, even if they do not have access **THE FILM ALSO HAS FINER GRAIN CHARACTERISTICS THAN STANDARD BLACK AND WHITE FILM.** to more expensive custom labs. The film also has finer grain characteristics than standard black and white film, and therefore yields beautiful enlargements. Negatives from C-41–processed black and white film can also be printed at custom labs to yield sepia or brown-toned photos.

OPPOSITE PAGE: If you want a print to put in your photo album or hang on the wall, color print film will be your film of choice.

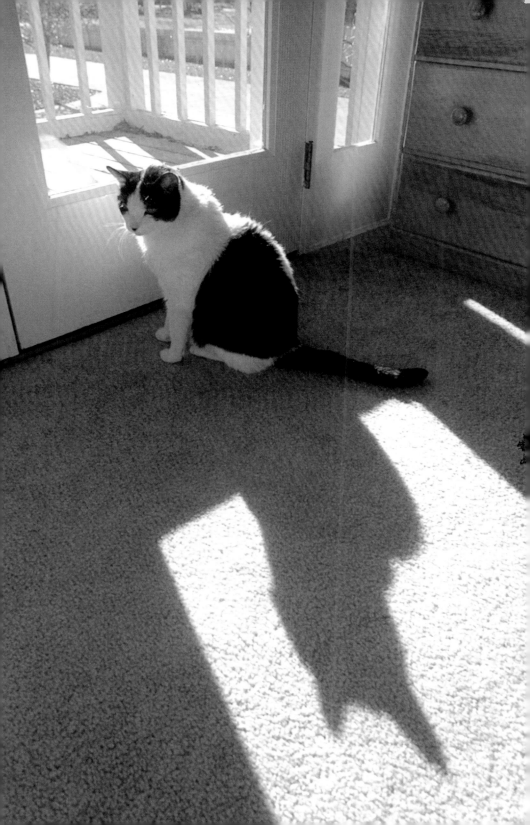

C H A P T E R

2

YOUR PET'S BEHAVIOR

*Undestanding
Your Subject*

Like other special-
ized areas of pho-
tography, pet pho-
tography presents
unique challenges,
starting first with the
subjects' motivation
for having his pic-
ture made. Humans
come into a portrait
studio because they
want to have a
professional portrait
made—they choose to be photographed. Children
(especially very young children) may be the exception
to that observation, but as children grow older, a par-
ent can exert reason and logic (or perhaps mild coer-
cion) to convince even the most reluctant child sub-
ject to cooperate.

☗ *Your Pet as a Photographic Subject*
Pets are not especially interested in having their pic-
tures made. Unlike humans, they'll never fully appre-
ciate the value of having a photograph of a loved one

OPPOSITE PAGE: *Observation and understanding are the keys to capturing
keepsake images of your pet. A wide angle lens was used here to capture both
a cat and the dramatic shadow it cast upon its owner's carpet. With
patience, practice, and tenacity, you'll soon be shooting great pet photos.*

Animals won't understand the importance of making great pet photos, so just be prepared to walk away from a pet photography session if your subject is not in the mood to cooperate.

and, therefore, cannot fully understand the intrusion of a camera into their normal lives. Keeping that in mind will help the pet photographer approach his/her subjects with patience and empathy, and will ultimately contribute to a successful approach to pet photography. Spending time observing and trying to understand your pet's behavior before attempting to photograph him or her will contribute to your success as well.

SPENDING TIME OBSERVING AND TRYING TO UNDERSTAND YOUR PET'S BEHAVIOR WILL CONTRIBUTE TO YOUR SUCCESS.

● Starting Young

As is the case with most other pet training endeavors, you'll want to begin working with your pet at an early age. Basic obedience training techniques will not only provide satisfactory manners for day-to-day living, but will also prove to be helpful when working with

Begin taking photos of your pet as soon as you introduce him or her into your life. Not only will those early photos be great keepsakes for you and your family, but your pet will become more accustomed to picture-taking overall.

a pet in more formal photographic settings. (For more information on pet portraiture, see chapter 4.) If you've worked conisistently with your pet from a young age, you'll have a pet that is apt to be a patient (and therefore photogenic) subject.

☽ The Professional's Approach

The most successful professional wildlife photographers are those who have an intimate understanding of their subjects' behavior. Wildlife photographers spend weeks, months, and sometimes even years observing their subjects in pursuit of elusive images. They note the times of day their subjects are active, when they feed, where they feed, when they play, and when they rest. In short, they get to know them before they attempt to photograph them.

Living day-to-day with a pet offers exceptional opportunities to observe your pet's behavior, just as a professional wildlife photographer would observe his/her subjects in the field. You probably already know, for example, what your pet's favorite toy is. You know the times of day when your pet is active and playful. You also know what makes your pet happy—and probably even what frightens your pet. All of these observations will help you anticipate the best time to capture spontaneous or candid photos of your pet.

LIVING DAY-TO-DAY WITH A PET OFFERS EXCEPTIONAL OPPORTUNITIES TO OBSERVE YOUR PET'S BEHAVIOR.

☽ Providing a Safe Environment

In taking our pet's photographs, we can capture some of our most treasured memories. Be sure to consider your pet's safety and well-being before engaging in a photographic session.

With time, even the most elusive pet subjects will become more comfortable with having a camera pointed in their direction. Photographing animals in safe, comfortable surroundings will certainly help reduce the fright factor.

EMOTIONAL WELL-BEING. Some pets are, by nature, more easily photographed than others. Some tend to become anxious when having their pictures made, while others are seemingly unconcerned. Some pets are responsive to obedience commands, others couldn't care less. But even if your pet is elusive, or even reclusive, you can still get him used to your photographic endeavors by letting him see you with your camera as often as possible—even if you're not taking pictures.

Many pets can become frightened when a human points a camera at them—in fact, many humans are equally frightened by that prospect. Making your camera part of a pet's normal environment can reduce the "fright factor" when you're ready to take a pho-

tograph. If your pet is used to seeing you with your camera, any negative reaction to it should be minimal.

Pets, like people, can be cooperative at times, but less-than-cooperative at others. If taking a photograph of your pet causes either of you to become upset, don't force the issue. In the long run, a slow, patient approach will yield significantly better results than creating unnecessary anxiety in the pet. By keeping the situation calm and normal, the pet will be less likely to associate your camera with anxiety.

Photography should be fun for the pet and the pet owner, so avoid creating a tense environment during your shoot. Your pet will be around for a long time. If you miss a great photographic moment this time, you'll likely have another chance later. Nothing, not even a great photo, is more important than having a loving relationship with your pet.

IF YOU MISS A GREAT PHOTOGRAPHIC MOMENT THIS TIME, YOU'LL LIKELY HAVE ANOTHER CHANCE LATER.

PHYSICAL WELL-BEING. Creating a safe shooting environment for your pet is of premier importance. Animals photographed outside and off-leash should be in an area where their safety is ensured, away from traffic hazards and other animals that could pose a safety threat.

Photographing pets performing certain feats or tricks can also make great photos. However, the safety of the pet, not the uniqueness of the photograph, should dictate whether or not to make a photograph. Pets will often go to great lengths to please their owners, so it is up to you to make certain no physical harm will come to your pet during a photo shoot.

Parks and other natural environments can provide picturesque backdrops for photographing pets, but be

certain to follow all local and state regulations regarding pet handling in public areas. Even the most well trained pet can succumb to impulsive behavior, darting out into traffic or chasing another animal. Every year thousands of pets are killed by cars and trucks. Keeping your pet safe at all times (especially during the photo shoot) will prevent your pet from becoming another statistic.

Pet handling regulations are designed for the safety of your pet as well as the safety and well-being of other people and other pets, so please read and follow all local and state pet regulations.

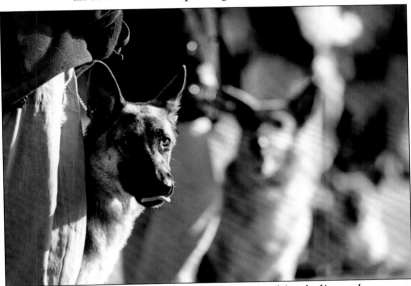

Even though this German shepherd is well trained in obedience, her owner has her safely on a leash while not at home. Obeying local leash laws and ordinances will help keep your pet safe at all times—especially during a photo shoot. (Although this dog appears to be sticking her tongue out at the photographer, most well trained pets are especially photogenic.)

C H A P T E R

3

THE RIGHT LIGHT

Seeing the Best Light for Better Pictures

Photography is all about light. Recording that light on film is what makes photographs possible. Seeing and recording the best light on film (and also knowing what times of day to avoid) is central to making great photographs.

🐾 *The Golden Hours*

With the exception of overcast days, the best times of day to take photos are from sunrise until about an hour after sunrise, and from about an hour before sunset through sunset. These times of day are often called the golden hours because of the warm, soft, golden light created by the sun. All colors in the scene are enhanced by this beautiful, natural light.

Not surprisingly, the golden hours are not always the most convenient times to shoot. But for scenics and portraits, the gorgeous light is worth the wait.

OPPOSITE PAGE: *Taking portraits of people and pets during the "golden hours" will likely produce positive results. The soft, golden light that occurs from sunrise for about an hour, and from about an hour before sunset to sunset, is picture-perfect light for almost any subject.*

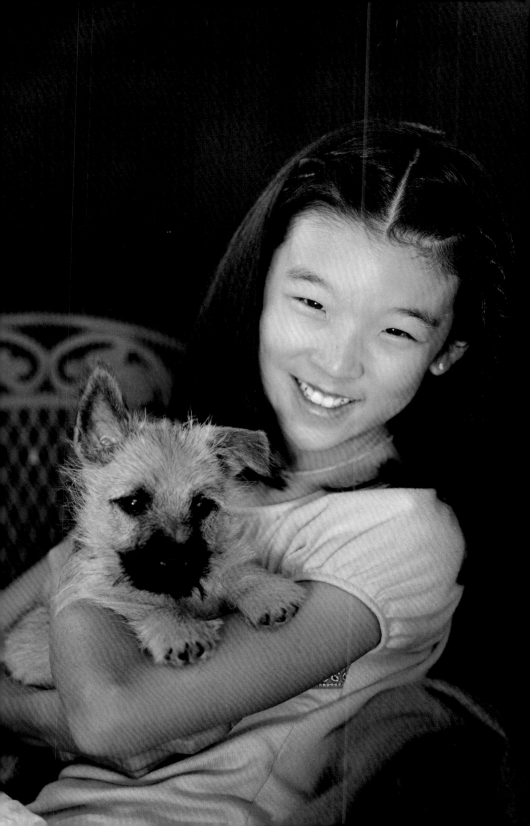

Backlighting

If you attempt to make a photograph when your pet subject is between you and the light source (commonly referred to as "backlighting"), you'll need to know what results you're likely to achieve, and how to overcome undesirable results.

Light meters in cameras are designed to "read" an average amount of light that is reflected in a scene in order to provide accurate exposure settings for your camera to make a properly exposed photograph. In backlit situations, however, your camera is reading the light source itself (not the light reflected off your subject). This will likely provide inaccurate exposure information to your camera because the meter is reading an intense light source. In most instances, your subject will be too dark, or underexposed, in the final print.

If you intend to shoot your pet in silhouette, this is the perfect lighting situation to achieve those results. However, if you want to take a photo of your pet in a backlit situation, but want to have your subject properly exposed, you have a couple of options, depending upon your camera's capabilities:

1. Use your camera's flash to provide adequate light to properly expose your subject. Some cameras provide a "fill-flash" option to add just the right amount of light to balance the light from behind with the light from the flash.

2. More advanced SLR cameras provide manual exposure override capabilities, which will give the pet photographer the option of allowing more light to expose the film than the meter suggests is necessary. Because light meter readings in backlit situations will cause underexposed subjects, allowing more light to reach the film will provide a proper subject exposure.

Most camera manuals provide details on how you can use your specific camera in backlit situations to achieve the results you desire. Be sure to take the time to read your camera's manual thoroughly in order to get the most from all of your photographic endeavors.

❖ *Overcast Days*

Overcast days create a soft, indirect light that is excellent for taking photographs. In the past, it was advised to avoid shooting on cloudy days. This was due, in large part, to the combination of slower film speeds and fixed exposure settings of yesteryear's cameras. But thanks to faster film and cameras with

Overcast days provide soft, even light, which is perfect for people-pet portraits.

The harsh light of day can cause deep shadows and stark areas of white, resulting in a less than desirable image.

adjustable exposure controls, shooting on overcast days is not only possible, it is desirable, especially for portraits and even some scenics.

Like the light during the golden hours, overcast light produces no harsh shadows with which to contend. Additionally, the color saturation (or intensity) of the film is increased, making the colors in your prints and slides look richer.

Red-Eye

Red-eye occurs when the light from your camera's flash bounces directly off the rods and cones on the back wall of the subject's eyes, giving the eyes a red, glowing appearance in the final prints.

One way to reduce red-eye is to lighten the room as much as possible. This will cause the pupils of the subject's eyes to constrict, and will reduce the area of potential reflectance. Cameras with built-in red-eye reduction provide a series of pre-exposure light emissions that create the same effect. The bursts of light cause the pupils in the eyes to constrict, thereby reducing the potential for red-eye.

If neither of these options are available, try having the subject turn his/her head at an angle to the camera to prevent the flash from having a direct line to the back of the eyes.

Indoor Lighting

Many of the situations that you'll want to photograph will be composed indoors. If there's not enough light and you're using an automatic camera, a flash may be activated in order to create a proper exposure—especially if you're using slower film speeds. But because the light comes directly from the camera, the flash can cause red-eye and undesirable background shadows. You'll find that there are just some situations that require indoor lighting. If possible, though, try moving your subject away from nearby walls to avoid the background shadows created by the flash.

It is important to note that, because most film is designed to be used in outdoor conditions or with a flash, shooting indoors under incandescent or fluorescent lights will cause the colors in your final prints to shift or change hues. Incandescent lights will cause a yellow color cast, while fluorescent lights will cause

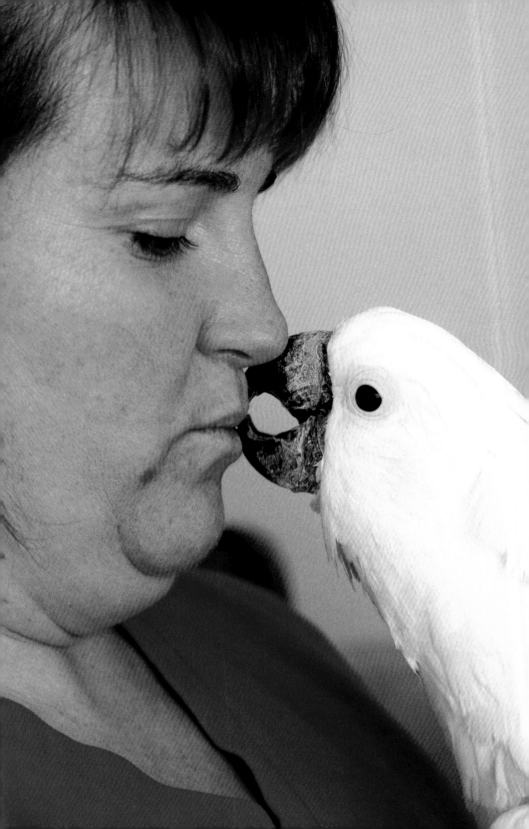

a green one. If you'll be shooting color images under indoor light, using print film (rather than slide film) is advantageous because most color labs can color-correct your final prints. Because black and white film renders colors in tones of neutral gray, it can be used effectively and without color shifts in any light.

☻ *Window Light*

Window light provides perfect light for some photographs. Soft light from a window can be a beautiful source for portraits, especially on overcast days. When photographing a subject using window light, be certain the light falls on half to three-quarters of the subject's face.

It makes sense that if the first and the last light of day are the best times to shoot photographs, one should avoid taking pictures in the middle of the day in bright sunlight. Midday light creates less than appealing skin tones, mutes colors, and creates harsh shadows on faces.

OPPOSITE PAGE: *Rather than using a flash, consider shooting with higher speed film and/or moving your subjects closer to a window to take advantage of more natural lighting.*

CHAPTER

4

COMPOSING PET PHOTOS

Creating Images with Impact

Whether you are shooting a spontaneous moment or documenting one that you've gone to great lengths to set up, your pet photographs will have more impact when you work at improving the photographic composition.

🐾 *Techniques for Instant Improvements*

Learning to shoot great pet photographs, like learning any new skill, takes time, patience, commitment, and sometimes luck. Fortunately, by utilizing four simple techniques, you can add instant impact and professional style to your pet photographs.

UTILIZING FOUR SIMPLE TECHNIQUES, YOU CAN ADD INSTANT IMPACT AND PROFESSIONAL STYLE TO YOUR PET PHOTOGRAPHS.

SEEK NEW PERSPECTIVES. For many, "if you've seen it once, you've seen it a hundred times" has become a mantra that represents the degree to which we have become visually desensitized to the world around us. We take pictures that reflect this limited perspective and, not surprisingly, our picture-taking has suffered for it.

Shooting at "pet level" (which may mean lying on your stomach to make the picture) can provide a unique perspective and add impact to your photographs.

For example, most photographs are taken from a height of five to six feet—the height of the average adult. It seems logical to shoot from this vantage point, doesn't it? Shouldn't we seek to create images that mirror the perspective from which we typically view life—the way we're used to seeing things?

Consider this: by simply changing your perspective, by making a photograph from a lower angle or

higher angle, you can transform the ordinary into extraordinary. In changing your perspective, you will change the way you see the world and, most importantly, you'll change the way the world sees your photographs. In **LEARNING TO SEE THE WORLD FROM A NEW** other words, you can **PERSPECTIVE WILL YIELD BETTER PHOTOS** add visual interest in **FOR YOU AND YOUR FAMILY.** your photographs by simply seeking a perspective that most picture-takers won't take the time to explore. A unique angle will often yield a unique photograph.

During playtime with a pet, you have probably gotten down on his or her level. If you're going to photograph a pet, it is often best to do the same. You might try shooting from a dramatically higher angle, looking straight down at your subject to provide a unique perspective. There are no rules for shooting from unusual perspectives. Good photographers are always on the lookout for an angle that will most effectively present the visual information they want to convey.

Your pet explores the world from a very unique perspective; you, in turn, should look for unique photographic perspectives from which to photograph your pet. Learning to see the world from a new perspective will not only yield better photographs for you and your family, it will undoubtedly yield a heightened sense of visual awareness and pleasure in your day-to-day life. How's that for an incentive?

A change in perspective offers another important benefit—it serves as a great tool in eliminating distracting elements like telephone poles or other eyesores that might adversely affect your photograph.

GET CLOSE! The biggest mistake made by most beginning photography students is shooting their pic-

By far, the biggest mistake amateur photographers make when shooting photographs is not getting close enough (left). By getting closer, there are fewer distractions in the scene to compete with the subject (below). When it comes to photographs, closer is almost always better.

tures too far away from their subjects. I urge (rather, implore) beginning students to get closer to their subjects. One way to make sure you're close enough is to fill the viewfinder with only the most important visual information before snapping the shutter. By simply getting closer, certain visual distractions (i.e., trees, power lines, telephone poles, etc.) in the photograph are eliminated. If you can't physically get close to your subject, use a telephoto lens. Whatever your method, closer is almost always better.

Perhaps the best philosophy in composing a picture is waste not, want not. Think of photographs as containing precious space. Don't waste that space on unimportant or distracting elements. If you follow my advice and fill the viewfinder with only the most important information before you shoot, your photographs will have much more impact. Plus, by getting close, the subject of the photograph becomes obvious—especially to those who see your images in scrapbooks or in picture frames.

One brief technical note—while closer is usually better, you need to be aware that there is a limit to how close your particular camera can focus. Most point and shoot cameras (those that do not require manual focusing or light controls) have a minimum

Getting close enough to fill the camera's viewfinder with the subject and using a unique perspective helped give this photograph much greater impact.

focusing distance of two to three feet. If you shoot an image closer than that, it will not be in focus. Be sure to read the camera's manual to see how close you can get with your camera.

Don't Hit the Bull's-Eye! To create impact in their photographs, photographers arrange objects in a manner that creates order and increases visual interest. The process of arranging the elements in a scene is called composition. Well-composed photographs provide a clear focal point, a point of visual interest that results in a photograph that is both easy and pleasant to view.

PHOTOGRAPHERS ARRANGE OBJECTS IN A MANNER THAT CREATES ORDER AND INCREASES VISUAL INTEREST.

In viewing a well-composed photograph, the eye takes in the many elements of a composition with ease. It is the photographer's job to decide what elements will be in the photograph, and how those elements should be arranged. Practically speaking, this means the photographer will determine how close to get to the subject and what angle or perspective would best suit the composition.

One surefire way to create good composition in your photographs is to avoid placing the subject in the center of the frame. Beginning photographers need to work hard to avoid the bull's-eye effect. Focusing aids and light meters in cameras are placed in the center of the camera's viewfinder, so many people incorrectly assume that is where they should place the subject.

To create visually pleasing images, try using a compositional technique called the rule of thirds. When used properly, it can guide you in subject placement—you'll never fall prey to the dreaded bull's-eye effect again! Looking through the

Above, the subject is right in the bull's-eye and the image lacks good composition. In the image on the right, the rule of thirds was employed to improve the composition. The format is vertical rather than horizontal now, and the image has much more impact.

viewfinder, imagine that the camera's frame is divided into equal thirds, both vertically and horizontally—sort of like an elongated tic-tac-toe grid. Try to place your subject away from the center, and near one of the quadrant intersections.

The rule of thirds is also helpful when photographing a landscape in which the horizon is a compositional element. Whether you're shooting a horizontal image or a vertical one, avoid dividing the picture in half with the horizon line. Instead, place the horizon in either the top third or lower third of the frame. This will significantly improve the composition, adding impact and interest to your pictures.

There are no hard and fast rules in photography. Although I recommend avoiding the bull's-eye effect, some centered subjects work well compositionally. In general, though, by using the rule of thirds, you will improve the results of your photographic efforts.

Keep in mind that if your photographic composition wasn't exactly what you wanted when you made the original photograph, a custom photo lab can crop (resize) the photograph. Often, photographs can simply be trimmed to enhance the composition.

SLOW DOWN, SHOOT MORE. In the hustle and bustle of today's lifestyles, many of us find it difficult to slow down. Learning to slow down, however, is precisely what you need to do to improve your photographs, and perhaps your appreciation of the world around you, as well.

"Good seeing" is the key to good photography, and good seeing requires good footwork. In order to shoot from unique perspectives, capture the right light, and properly frame your subjects, you'll need to

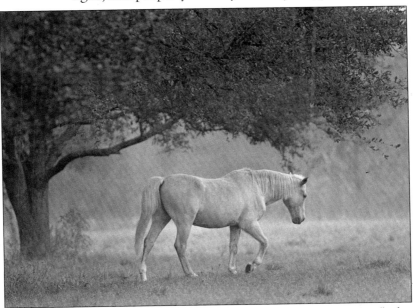

With practice, you'll automatically compose the scene in your viewfinder with the rule of thirds in mind. Although there are exceptions to using the rule of thirds, most photographs, like this one, benefit from the use of that compositional technique.

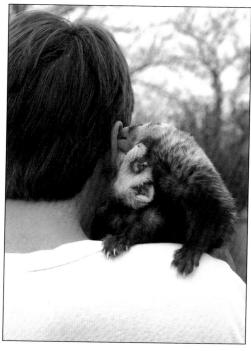

Some pets, like these playful ferrets, enjoy close human contact. Moments like these only last an instant, so it pays to be prepared and to be ready to shoot several frames quickly when the right moment develops.

use your feet. Once in position, take the time to soak it all in, and decide what angle or perspective will make the best picture(s).

Most amateur photographers simply "grab" pictures in a moment's haste. Successful photographers know that there's no point to shooting the photo until it is properly composed. Before taking the photograph, really

SUCCESSFUL PHOTOGRAPHERS KNOW THAT THERE'S NO POINT TO SHOOTING THE PHOTO UNTIL IT IS PROPERLY COMPOSED.

explore your subject. Look at it from different angles; observe from above, below, and from various sides. See the world through your viewfinder, then ask yourself which of the possible angles will make the best picture.

After you've slowly and thoughtfully composed the scene, wait for the right moment to take the pho-

tograph. Sometimes that means waiting for your pet to get into the right position, or to do a particular trick. *When* you take the picture actually determines the quality of the picture. Achieving the right feel for your photograph is worth the wait.

When the right moment finally comes along, shoot several frames. Carefully considered compositions are the mark of a successful photographer, and when you slow down and capture the feel of the moment, you'll preserve cherished memories (not to mention beautiful photos). With the "slow down, shoot more" approach, you're guaranteed to achieve a more professional look.

By using the "slow-down, shoot more" technique, you'll be ready to capture wonderful moments, like this one between a dog and his owner.

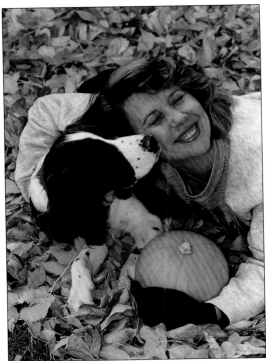

5

PEOPLE AND THEIR PETS

*Preserving
Great Memories*

Our lives wouldn't be the same without our pets, and most pet owners treasure photos that feature them with their pets. While some of those photographs are spontaneous and candid, and others are planned, all are cherished.

🐾 *People and Pet Portrait Challenges*

The previous chapter covered four simple techniques for improving the visual impact of your pet photographs. While those tips will come in handy for making portraits of *individual* people and pets, combining people and pets in a portrait sitting poses some unique challenges.

KEEPING BOTH SUBJECTS SHARP. A good people-pet portrait shows both subjects sharp and in focus. Depending on the light, the film speed, the focal length of the lens, and how close you are to the subject, you may

A GOOD PEOPLE-PET PORTRAIT WILL SHOW BOTH SUBJECTS EQUALLY SHARP AND IN FOCUS.

only have an inch or two of depth of field (the area of a photograph that is acceptably sharp and in focus).

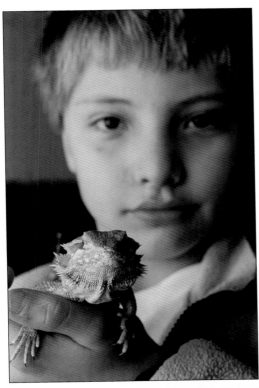

LEFT: *The bearded dragon is sharp, but because the child is not on the same plane as the pet, the child is out of focus.*

BELOW: *The bearded dragon and the child are on the same plane, and both subjects are rendered equally sharp.*

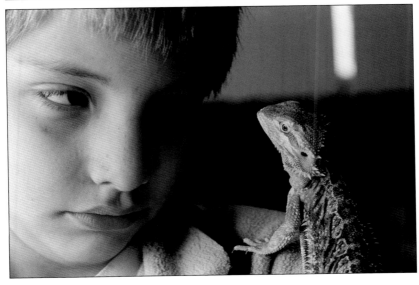

To keep both subjects sharp, position them so that their heads are on (or nearly on) the same plane of focus. In other words, the person and the pet should be as close to the same distance from you as possible. If one is closer to the camera, you may not have enough depth of field to render both subjects sharply focused.

ELIMINATING DEAD SPACE. "Dead space" is the term for an area of a photograph that does not contribute to the image's composition. In a two-subject portrait, this generally occurs when one subject's head is on one side of the photo, and the other subject's head is **"DEAD SPACE" IS THE AREA OF A PHOTO-GRAPH THAT DOES NOT CONTRIBUTE TO THE IMAGE'S COMPOSITION.** on the other side of the photo. The space between the subjects' heads (if there's too much of it) is considered dead space.

You can minimize the amount of dead space by positioning the subjects as close together as possible. For a small pet it may be possible for the subject to simply hold the pet up near the face. In photographing a larger pet, the person may stand or kneel and lean into the pet to cut down on dead space.

Backgrounds

Finding an appropriate background to make your pet portraits is an important element in your endeavors as a pet photographer. Sometimes you simply won't have to worry about the background because you've filled your camera's viewfinder with the subject, and there's no background with which to contend.

OPPOSITE PAGE: By bringing a pet and person close together, you'll be able to keep both subjects equally sharp and in focus, and you'll eliminate the dead space that can occur when two subjects are too far apart.

Simple Backgrounds

Here are some additional suggestions for keeping the background in your photos simple:

1. When setting up your portraits, avoid walls and backgrounds with strong lines or distracting colors.

2. Try to move your subject as far away from walls as possible.

3. Shoot with a telephoto lens and fill up the frame with as much of your subject as possible—there's little chance that you'll have a busy background if your subject is blocking it from view.

However, some full-length (or full-pet) photos will require that you consider the impact your background will have on your final pet portrait. As is so often the case in photography, less is more. Seek simple, non-distracting backgrounds. The less distractions you have in a background, the less visual competition you'll have in your picture. The result: a simple and effective portrait.

THE LESS DISTRACTIONS YOU HAVE IN A BACKGROUND, THE LESS VISUAL COMPETITION YOU'LL HAVE IN YOUR PICTURE.

Instructions for Humans

Because you'll have your hands full with technical, compositional, and posing concerns, you can ask your subject to keep his eyes on you during the entire sitting. This will allow you to concentrate on the technical aspects of the shoot, and focus on getting and keeping the pet's attention so that you can take the picture. A pet may only provide you with one or two chances at a good shot during a sitting, and the last

thing you want is to have the pet's attention while the human subject is looking off camera.

Having a helping hand to assist in getting and keeping a pet's attention will bolster the odds for a successful session. A friend or family member can be

HAVING A HELPING HAND TO ASSIST IN KEEPING A PET'S ATTENTION WILL BOLSTER THE ODDS FOR A SUCCESSFUL SESSION.

a great assistant with just a few simple directions. First, ask the assistant to stand directly beside (or immediately behind) you with a toy, treat, or other attention-getting device. Then prompt the assistant to get the attention of the pet during the actual photo shoot. When things look good through the viewfinder, take the photo!

🐾 Expect Some Surprises

Some surprises are more pleasant than others. A pet may not be eager to have his portrait made, and may run, jump, fly, scurry, or scratch his way to freedom. It may be necessary to try several times to make a good portrait, or you may simply have to walk away and hope for a better session next time. Remember that no matter how important a pet photograph is to us, our pets are always more important. Always make the pet's welfare your first priority.

Of course, you may also be pleasantly surprised by a pet's reaction to a portrait session. The pet might give in to an impulse to show affection toward its owner. Preparation is the key to turning those spontaneous moments into classic photographs!

CHAPTER

6

PET CANDIDS

Photographing Your Pet at Play and Rest

Like people, no two pets are alike. In addition to the obvious physical differences between them, each individual pet has his/her own unqiue personality and behavioral characteristics. Capturing these unique differences is one of the most rewarding aspects of pet photography. It also poses some of the greatest challenges.

☙ *If at First You Don't Succeed . . .*

It is doubtful that there's a photographer alive who hasn't missed a photographic moment at some point in his or her life. Those moments can be missed because of being a millisecond late squeezing the shutter. Sometimes

CAPTURING SPONTANEOUS PET PHOTO-GRAPHS REQUIRES A COMBINATION OF LUCK, TENACITY, AND CONCENTRATION.

those moments can be missed because of a focus or exposure problem.

The truth is, capturing spontaneous pet photographs requires a combination of luck, tenacity, and concentration.

Tips for Being Prepared

Here are a few tips that will help you prepare to capture those moments:

1. Always have your camera loaded with film. There's nothing more frustrating than seeing a great moment develop before your eyes, grabbing the camera, then realizing that your camera is out of film.

2. Make certain that your batteries are fresh. Old batteries take longer to activate and recharge your camera's systems. In the time your camera's systems are recharging, your wondrous pet moment may disappear.

3. Keep your camera in a readily-accessible place (like on top of your refrigerator). By consistently placing your camera in a designated spot, you won't spend valuable seconds rummaging through your drawers, trying to locate your camera. Other family members can also seize those candid moments if they, too, know where the camera is.

4. Move quickly, but quietly. Noise and commotion can disrupt a spontaneous moment. In keeping your movements as quiet as possible, you can approach the subject without disrupting the spontaneity of the moment.

Being Prepared

About 90% of pet photography is luck. But good pet photographers are consistently lucky. In other words, good pet photographers are prepared and ready to shoot those wonderfully spontaneous moments as they occur. Not surprisingly, one of the most critical components of candid pet photography is having your camera loaded and readily accessible at all times.

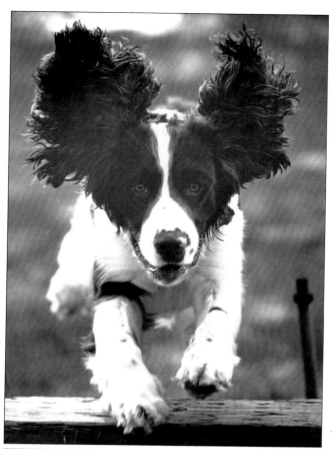

LEFT: *Photographing your pet at play can require several attempts to capture just the right moment. The key to capturing this moment was focusing on a preselected area, then waiting for the dog to jump through that area. It took several frames of film to get this one right.*

BELOW: *Even when pets are at rest, having your camera close at hand can be the difference between capturing a wonderful image and missing the moment.*

☙ Some Useful Lenses

Capturing spontaneous images of your pets at play can be made easier with the use of a couple of very important tools—telephoto and zoom lenses. As described in chapter 1, these lenses allow the photographer to close in on a subject without actually moving physically closer. As you can imagine, this will allow subjects to be photographed from a distance without disturbing the spontaneity of the event. Telephoto and zoom lenses can provide a more comfortable working distance for pet portraits as well (see chapter 4).

Unfortunately, because you'll be taking photographs at greater camera-to-subject distances while using telephoto lenses, your camera's flash may not produce sufficient light to make a proper exposure.

☙ Flash Falloff

The flash you're using has limitations regarding its maximum operating distance (the maximum distance from a subject at which it can be effectively used to make a proper exposure). In general, when using 400 ISO film, the maximum operating distance for most built-in camera flashes is twenty to twenty-five feet. The intensity of your camera's flash is reduced significantly the further you are from the scene you are shooting. That reduction in light is called falloff; it greatly limits the operating range of your flash. Be sure to check your owner's manual for specific instructions regarding your camera's flash operation and keep that information in mind if you're shooting with a telephoto lens and flash combination.

YOUR CAMERA'S FLASH MAY NOT PRODUCE SUFFICIENT LIGHT TO MAKE A PROPER EXPOSURE.

TOP: *A telephoto lens can come in very handy when you don't want to disturb your pet subject. A telephoto lens was used here to capture, from a distance, a watchful dog guarding his owner's home.*

BOTTOM: *Zoom lenses provide varying focal lengths for picture-taking. Photographers can choose the most appropriate focal length (from wide angle to telephoto) to capture their images. Here, the telephoto part of the zoom lens was used.*

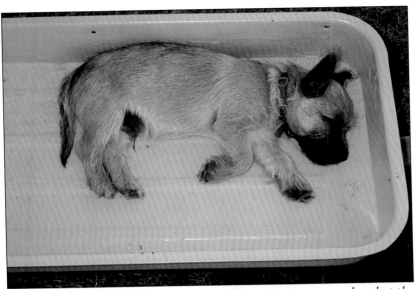

If you must use a flash to capture a special pet moment, remember that the useful range of most built-in flashes is ten feet. If you're further away, your film may be underexposed.

☙ Capturing Candids Indoors

Although flash photography can help produce well-exposed photographs under certain conditions, using higher speed film might be a better all-around solution for shooting indoors without a flash. Several manufacturers produce color print film with film ratings of 400–1000 ISO. These higher speed films can be used under lower light conditions.

There's an inverse relationship between film speed and the amount of light that is required for proper exposure: the higher the speed, the less light needed to take a properly exposed photograph. Higher-speed films tend to produce more grain on the final prints or slides. The larger the grain, the lower your photo's resolution. However, unless you're enlarging photographs to more than 8"x10", this shouldn't be a problem.

CHAPTER

7

EXOTIC EXPOSURES

*Photographing Our
Unique Animal Friends*

While many people enjoy the companionship of pets from the more traditional canine and feline families, many others enjoy more unique and diverse animal friends. From frogs to ferrets, from horses to hogs, the world of pets is no longer the exclusive domain of dogs and cats. Animals that have traditionally had homes on farms or in remote exotic locations now share our homes with us.

Like their traditional pet owner counterparts, exotic pet owners are interested in making quality images of their pet friends. This chapter is devoted to addressing some of the unique considerations in photographing these animals.

● *Pet Safety*

Some animals, like fish and other aquatic species, can never be safely handled outside of their unique environments and should never be exposed to any conditions that could threaten their well-being. Specialized lighting and photographic equipment is generally

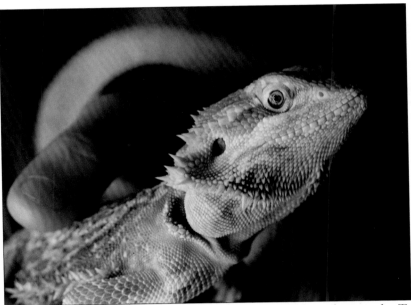

Pet safety should always be the most important aspect of pet photography. To make this photograph, a bearded dragon was safely placed in the gentle hands of its owner.

required to successfully photograph our aquatic pets. Photographers interested in learning more about aquatic photography can check their local libraries or search the worldwide web for specific information on this unique genre.

Others animals can be safely removed from their traditional environments and photographed with their owners.

Natural Light, Natural Success

One of the keys to successful pet photography is choosing the right light. Although most consumer cameras today have built-in flash capabilities, photographing pets in natural lighting conditions will almost always yield more natural looking images. In addition to creating undesirable shadows, red-eye,

 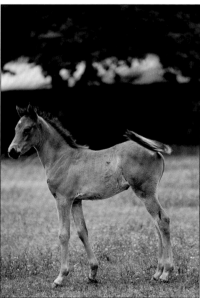

LEFT: Using ISO 400 speed film in a room with lots of natural light made camera flash unneccessary for this photo.

RIGHT: Consider photographing your pet or animal friends in environments that are more natural. The light will likely be better, and the animal will also be more comfortable.

and washed-out photographs, flash photography may also cause anxiety in some pets.

Advances in film and digital technology provide today's photographers with tools to photograph pets in more natural lighting situations without the use of flash. Color print film is available in speeds up to 1600 ISO, and all but eliminate the need for flash photography in the majority of shooting situations. (See chapter 6 for more details.)

If possible, photograph the pet in its environment. He or she will be comfortable there, and you will likely encounter sufficient natural light to make the photograph.

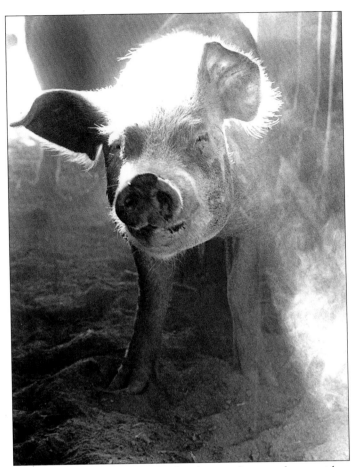

Even pigs can be pets, and what better place to photograph a pig than in its natural environment, on the farm?

☀ Closer Is Better

As noted in chapter 4, successful pet photography, like almost all other areas of photographic endeavor, hinges on keeping the photo simple. And frequently, photographic simplicity is a function of proximity. When it comes to taking great pet photos, closer is almost always better. For larger pets (horses, dogs, pigs, etc.), closer is simply a matter of making a con-

LEFT: *Keep the background as simple and non-distracting as possible. To achieve this, choose a plain background, move your subjects as far from the background as you can, and shoot with a telephoto lens if possible.*

RIGHT: *As is the case with most successful photographs, closer is better. Careful focusing and patience is critical for success.*

scious effort to get close enough to fill the frame with the photographic subject.

However, photographing small pets can present unique technical challenges. Because most standard lenses are unable to focus on objects closer than two feet away, getting close enough to fill the frame may not be possible (see chapter 1).

☙ *Macro Lenses for Micro Pets*

Macro lenses are specially designed for close-up work and are available for most single lens reflex 35mm cameras that feature interchangeable lenses. These lenses can focus on objects as close as a few inches

away, allowing photographers to make images of the smallest of pets.

Despite their advantages, macro lenses have some limitations regarding depth of field. Again, depth of field is the part of a photograph that is acceptably sharp and in focus. Lens length, aperture, and camera-to-subject distance each affect depth of field. Because close proximity to a subject permits limited depth of field, a photo taken at a distance of several inches from the subject may have a depth of field of only centimeters.

DESPITE THEIR ADVANTAGES, MACRO LENSES HAVE SOME LIMITATIONS REGARDING DEPTH OF FIELD.

Accurate focus with these lenses becomes crucial. Ensure that the eyes of your pet appear acceptably sharp, and concentrate on keeping the eyes in focus as the pet moves. This will require intense concentration on the part of the photographer, but will yield stunning photographs when successfully executed.

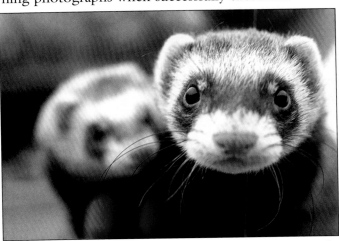

Using a macro lens will allow you to get close to even the smallest of pets, but photographing subjects up close requires concentration and a sharp eye. To make a great pet photo, your subject's eyes must be sharply focused.

CHAPTER

8

SHARING AND CARING

Tips for Displaying Your Images

By following the basic picture-taking advice in this book, you'll be well on your way to shooting great photos of your pet friends for years to come. Because no one knows your pets like you do, and because you spend so much time with them, you'll have the unique opportunity to capture many memorable photos. With time, practice, and tenacity, your pet photographs will continue to improve and your cache of keepsake photos will swell.

But what do you do with those prize-winning photos once you have them in your hand? This chapter explores some of the many ways you can use your photographs for fun, and maybe even a little profit.

❧ *Editing*

When you get your processed film back, the first step in using your photos is to decide which ones *not* to use. When you slow down and shoot more, you'll probably end up with several frames of each scene, subject, or expression. Take a tip from the pros—

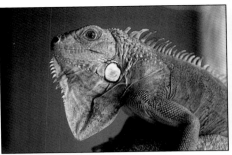

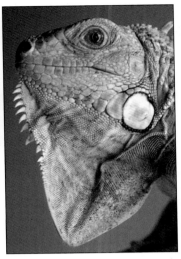

No matter how you use or display your photographs, cropping an image can sometimes improve its visual impact. Here, a good photograph of an iguana is made even more dramatic with tight cropping.

choose the best images and set the others aside. Look for images with good exposure, good composition, and interesting subjects. Once you have your favorites, you can decide how to use them.

☻ *Enlargements*

With some of your most special images, you'll probably want to have enlargements made for framing and decorating your home or office. When making enlargements, keep in mind the film speed that the

WITH SOME OF YOUR MOST SPECIAL IMAGES, YOU'LL PROBABLY WANT TO HAVE ENLARGEMENTS MADE FOR FRAMING.

image was shot on. If you used film with an ISO or ASA of 400 or more, you'll probably want to enlarge a 35mm or APS negative to no more than 8"x10". If you used a slower film, you can probably get good results with prints up to 16"x20".

If possible, take the original print, along with your negative, to the lab. If you are happy with the colors in it, let them know that you'd like the enlargement to match it as closely as possible. If the

Aspect Ratio

When purchasing enlargements, it is also important to keep in mind that the aspect ratio (the proportion of height to width) of your negative may be different than the aspect ratio of some print sizes. As a result, when the enlargement is made some cropping may occur. Often, this is no problem. If something in your photo runs close to the edge of the print and you want to make sure it doesn't get cropped off, however, you'll need to provide special instructions when you place your order.

original print isn't quite right (let's say you shot the picture in incandescent light and it has a yellow color cast), tell them that, too. Often, this can be corrected in a reprint or enlargement.

If you have access to a custom photo lab, you can consider having images cropped, if that will improve the composition or remove a distracting element. Cropping simply means that the lab prints only part of the negative instead of the whole.

You can also neatly trim the images yourself, using a sharp paper cutter or razor blade. You can also use scissors, but these can produce an uneven edge.

Keep in mind, when you crop or trim an image, you will more than likely end up with an image of a nonstandard size. This means you'll be less likely to find off-the-rack frames and mats to fit it.

Seasonal Cards

When it comes to making your own seasonal cards, many photo processors provide a variety of printing options, especially at holiday time. For most families, a family photo simply wouldn't be complete without

their beloved pets. For variety, or just for fun, you may wish to consider featuring just your pet on the card. Don your pet in some form of holiday attire, like a bow or a set of antlers, and your personal holiday card is sure to bring smiles to whomever receives one.

There's nothing like a holiday photograph of your pet to put a smile on the faces of your friends and family.

☙ *Personalized Calendars*

Today's color printing technology provides an opportunity to print attractive, inexpensive calendars. Many quick-copy vendors provide color printing services that will allow you to feature one or more of your personal pet photos on calendars and other printed materials. By using some of your own great pet photos on a calendar, you'll have a monthly source of pride and inspiration—not to mention a visual reminder of your wonderful pet friends.

❧ Shirts and Mugs

The same technology that provides the means to print color photographs for personal calendars can also be applied on other novelty items. Color T-shirts, sweat-shirts, coffee mugs, plates, and mouse pads are all great media for your pet photos. You'll be amazed at what wonderful conversation starters those items can be—especially with other pet lovers!

❧ Photo Contests

Taking great pet photographs is a thrill in and of itself. But winning the accolades of others can be even more rewarding. From local pet store and veterinari-an contests, to national magazine contests, there are literally hundreds of opportunities to compete for fun and prizes. In addition, many state and county fairs feature pets as part of their photographic categories. From time to time, magazines (like *Parade*) feature pet photography con-tests. Also, pet photography magazines and newslet-ters sometimes provide contest opportunities.

COLOR T-SHIRTS, SWEATSHIRTS, COFFEE MUGS, PLATES, AND MOUSE PADS ARE ALL GREAT MEDIA FOR YOUR PET PHOTOS.

A search of the worldwide web will yield many more opportunities. One site (<amateurphoto. about.com>) provides a listing of a wide range of photography contests, both on- and off-line.

❧ Internet Web Sites

A pet photograph can provide a great visual for almost any home page, including your own. Web sites that feature products or services for pets are potential sources for featuring your pet images. To find out if you can sell or feature your pet photos on a particular pet web site, contact the webmaster of that page.

❦ *Books and Magazines*

The *Photographer's Market* (published by Writer's Digest Books) lists thousands of book, magazine, and mass-produced greeting card publishers interested in great pet photographs. In this market, you'll be competing with professional photographers, but the best pet photographs are often those candid, spontaneous, one-in-a-million images that only you could take of your pet in a rare moment.

❦ *Scrapbooks*

No scrapbook or family history photo book would be complete without our pet family members. Be on the lookout for great photos of your pets as they interact with other family members. These photos can be the cornerstone of your scrapbooking endeavors. .

No matter how you might use your photos, a well-thought-out photograph of a pet in his environment will likely make a wonderful keepsake.

❧ *Framing and Matting*

Despite the growing use of technology for displaying and disseminating photographs, there's still no place like home (or your office) for great pet photos. Whether they're professionally matted and framed or self-matted and framed, pet photographs can bring life, color, and fun to almost any room. The key to great framing and decorating success starts with great photos. Once you have great images, your decorating choices are nearly limitless.

No matter how you use your pet photos, sharing them is simply one more way of caring for your pet friends. There's nothing (short of actually being with a pet) that will put a smile on the face of animal lovers throughout the world like a great pet photo.

To Learn More

For more information on photographic techniques, consult one of the many books published by Amherst Media, Inc., which span an extensive number of topics (www.Amherst Media.com). In addition, using various search engines, you can search by photographic subjects on the Internet for information on cameras, film, photographic accessories, handcoloring, and other subjects. Sites such as www.iwon.com; www.yahoo.com; www.dogpile.com; and www.metacrawler.com are good places to start your search. Canon, Nikon, Olympus, Minolta, Contax, Pentax, Kodak, Fuji, Ilford, Agfa, and other companies all have Internet home pages with up-to-the minute information on their specific camera and film products.

Glossary

Advanced Photo System (APS)—A camera and film system that offers drop-in film cartridges, multiple print formats (including panoramic view), in-cartridge negative storage and other features.

ASA—A film speed rating similar to ISO that indicates a film's sensitivity to light.

Backlight—A lighting situation in which the primary light source is behind the subject.

Bull's-eye effect—Centering a photographic subject in the viewfinder, creating a static, unappealing composition.

C-41 black and white film—A film that produces black and white prints, but is processed with a color negative film process (called C-41).

C-41 process—The chemical process by which color film is converted to color negatives.

Color cast—A trace of a color throughout the entire photo (generally undesirable).

Color correction—A procedure by which color cast or balance can be corrected during the printing of a color photograph.

Color negatives—Processed color print film. The color negative is used to make a positive, or color, print.

Color print film—Film that is used to create color prints.

Color transparency film—Positive images created on a transparent film base for projected viewing. Also called slide film.

Commercial lab—A photographic processing lab, generally used by commercial professional photographers, that can provide special photographic services for processing film or printing images. Also called custom lab.

Composition—The positioning of elements in a scene to create visual impact and to imply depth in a photograph.

Custom lab—See commercial lab.

Dead space—Any area in a photograph that does not contribute to the composition of that image.

Depth of field—The area of a photograph that is acceptably sharp or in focus. Three factors (lens focal length, camera-to-subject distance, and aperture) control how much depth of field will be in a photograph.

Digital cameras—Cameras that use electronic information, rather than film, to record an image.

Exposure controls—Camera settings, either automatic or manual, that allow light to expose the film through the camera's lens and shutter. The amount of light that reaches the film is controlled by the aperture (lens opening) and shutter speed (length of time the shutter is open).

Film—The light-sensitive material used to record a photographic image.

Film speed ratings—Film speed ratings (ISO or ASA) indicate a film's sensitivity to light and are expressed in numbers ranging from 25 to 3200. The higher the number, the less light required to adequately expose the film.

Flash falloff—The rate at which the intensity of a camera's flash diminishes, or "falls off," on its way to the subject.

Fluorescent light—A light source in which light and invisible (ultraviolet) radiant energy are produced by electricity flowing through mercury vapor. In photography, shooting under fluorescent lighting causes a greenish color cast when shooting with a daylight-balanced color film.

Focal point—In composition, the part of the image to which the viewer's attention is most strongly drawn.

Focusing control—Controls, either automatic or manual, that allow the photographer to focus light through the lens onto the film in order to render a sharply focused subject.

Framing—A compositional technique that uses foreground objects in all or part of the scene to frame the subject and to create depth in the scene.

Golden hours—The time of day (usually from sunrise to about an hour after sunrise; and from an hour before sunset to sunset) that creates a dramatic and golden light that is ideal for most photographic endeavors.

Grain—In an enlarged image, the speckled or "grainy" look caused by silver in a negative.

Handcoloring—The process of applying, by brush or other method, color oils to a black and white photograph.

Incandescent light—Light emitted when a substance is heated using electricity, including normal household lighting.

ISO—A film speed rating similar to ASA that indicates a film's sensitivity to light.

Lens—A piece (or pieces) of optical glass that focuses the light from a scene onto the film.

Light meter—An instrument that measures the amount of light in a scene. Light meters in cameras measure the amount of light reflected from a scene in order to make a proper exposure.

Macro lens—A special close-up lens that allows for focusing on objects at very close distances.

Normal lens—A lens that "sees" a scene at roughly the same

angle of view that the human eye sees in a fixed position. For 35mm cameras, a normal lens is 50mm.

Perspective—The apparent size of objects in a scene relative to each other.

Perspective control—Using lenses and composition to affect the apparent size of objects in a scene.

Plane of focus—An imaginary plane where multiple photographic subjects are at an equal distance from the camera's film plane.

Point and shoot—Compact, easy-to-use, automatic cameras.

Proper exposure—Amount of light (controlled by the lens aperture and camera's shutter) required to render a well exposed (neither too light or too dark) image.

Resolution—The sharpness of a photograph or area of a photograph.

Rule of thirds—A compositional technique that divides the viewfinder into three equal parts vertically and horizontally to facilitate better photographic composition.

Shutter—The mechanism on a camera that opens and closes to expose the film.

Shutter speed—The length of time a camera's shutter remains open in order to render a proper exposure on film.

Single-use cameras—Preloaded, inexpensive cameras that are designed to be used once and discarded as part of the film processing. Also called disposable cameras.

Single lens reflex—A camera in which the image is viewed through, and is formed by, the camera's lens. A camera system that employs a mirror and viewscreen that allows the photographer to view the scene through the camera lens, where the image is formed, rather than through a separate window (viewfinder).

Subject—The person or object that is the main focus of a photograph.

Telephoto lens—Any lens with a longer than "normal" focal length. For 35mm photography, any lens in which the focal length is greater than 50mm.

Toning—The process of changing the overall color (or tone) of a black and white photograph.

Viewfinder—The small window found on some cameras through which a subject is seen and an image is composed.

Wide angle distortion—Objects or features that appear to be disproportionately larger or smaller than others when using a wide angle lens to photograph a subject.

Wide angle lens—Any lens with a shorter than "normal" focal length. For 35mm photography, any lens in which the focal length is less than 50mm.

Zoom lens—A lens that is adjustable to a range of focal lengths, often from wide angle to telephoto.

Index

Other Books from
Amherst Media™